HURRICane STORY

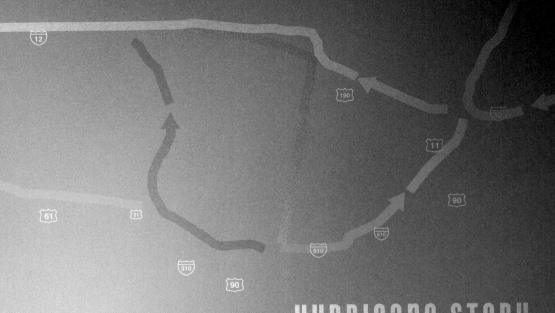

HURRICANE STORY

JENNIFER SHAW

BROKEN LEVEE BOOKS
an imprint of
CHIN MUSIC PRESS
SEATTLE
SUMMER 2011

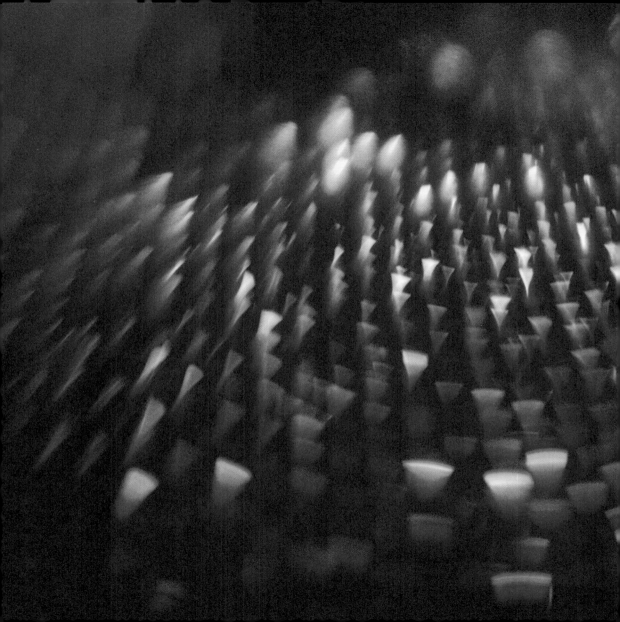

Any city worth living in strikes a balance between order and chaos. I guess any *life* worth living strikes that balance too. In late August of 2005, Jennifer Shaw's city, and I can only assume her life, tilted too far in one direction. The remarkable series of forty-six images collected in *Hurricane Story* tells the tale, and does so in a way that sets the balance right again.

From the first photograph, "We left in the dark of night," the viewer senses something about this journey is not quite right: a toy truck, in dreamy color, headed who-knows-where. Shaw and her husband, Cesar Sousa, drove out of New Orleans in the pre-dawn hours, just ahead of Hurricane Katrina. Shaw was due to give birth in less than a week.

Maybe this is how the world appeared to them? A vivid yet murky sequence, a prettily impressionistic series of environments that seem more like a place to wake up from than to inhabit.

If my memory is accurate, the American public did not immediately grasp what the rising water in New Orleans really meant. Hurricane Katrina had skirted the city and everything seemed, according to the TV set, to be in order. But those who knew the city also knew that rising water meant the engineering system that was supposed to keep the place from filling like a bowl had evidently failed. This inspired instant, visceral fears of a worst-case scenario: Some unprecedented form of chaos would arrive soon, and stay awhile.

My wife Ellen Susan and I had left New Orleans two years earlier – to Jen and Cesar we'd given some houseplants and a guitar. Now, from a distance, our efforts to check in on friends grew panicked. It was a few days before Ellen found these two, after a fashion, by way of an online article from an Alabama newspaper about the New Orleans couple who had fled Katrina and somehow found a midwife to deliver their child. A heartwarming and remarkable local-interest item, it was of course not the climax of a story, but the beginning of one. Months and miles would go by before this new family could come home from the road – or know if home would be the right word for whatever New Orleans became.

The tenth photograph in this book is titled "The next morning we turned on the TV," and the image – toylike houses, their warm red, yellow and green exteriors darkly reflected in water risen to the windows – remains among my favorites in the series. I suspect that anybody anywhere who cares about New Orleans had a moment when what had happened, what was *still* happening, really sunk in. This image of the houses captures that for me.

Disasters are supposed to be fast and furious – like a hurricane. The excruciating thing about the flooding and its aftermath was that it unfolded slowly and then came to a dead stop: It was just there, day after day, no improvement, only a methodical drip of bad news and worse. That Shaw manages to evoke that time, but with a sense of beauty and grace rather than stark misery, is evidence that she did something magical here.

If my summary in words so far fails to match what she communicates in her images, this is the spot where all that follows can *only* be told the way Shaw tells it, so I'll write no more of the actual story of *Hurricane Story*.

Another image is titled "The chaos was hard to fathom," and I think that feeling was widespread: For a while, the rumors were all facts and the facts were all rumors. When the waters receded, artists in every medium occupied, or became preoccupied with, New Orleans. Great works were created (not that anybody wouldn't happily trade them all for this never having happened), but I don't care to think of this one in quite that context. The story is also so personal. It struck me immediately as completely different from Shaw's own prior work, in a way I found startling. I never asked about her choices, because it all seemed just right: The colors, the tone, the impression of being in some world other than this one, which she essentially was. I never asked if she had considered a more "realistic" documentary approach, because these unreal tableaus of toys and tiny things arranged in uncertain light seemed so fearlessly right. Maybe it all simply extended from that curious totem, the plastic King Cake baby. Or maybe it was something else.

Few cities have answered the riddle of balancing chaos and order with the panache and insanity of New Orleans. Carnival stands as the most obvious example: An elaborate mosaic of traditions and rituals, hierarchical societies

and strictures formal and otherwise, precariously yet seamlessly organized to make space for anarchic disregard of self-control or social mores. It's perfect. But it's just an example. No other place I know so values the idea of ordering itself in a manner that accommodates chaos. That is for better and sometimes for worse, but accepting it (embracing it, really) is one of New Orleans' paradoxical rules. Lose all you know: This way.

The chaos that followed Katrina made anyone who cared feel like a small thing arranged into involuntary scenarios devised by unseen forces. Here, the artist arranges things, and in doing so restores wonderful order to her story, and her city's. The viewer can and really must fill in most of the blanks, reconcile the facts and rumors. The journey is emotional, a roller coaster, a flight, an exile, a series of tentative steps into undefined spaces. Visually it's the opposite of a traditional attempt to document an authentic reality, and that is precisely why it is so effective. *Hurricane Story* converts the chaos of life into the form of order that we call art. The final image affirms that the new family found home right where it was sought. Glittering high heels stride into who-knows-where, and you want to stand up and cheer. Find all you seek: This way.

Rob Walker
Savannah, Georgia
February 2011

I was nine months pregnant and due in less than a week when Hurricane Katrina blew into the Gulf. In the early hours of August 28, 2005, my husband and I loaded up our small truck with two cats, two dogs, two crates full of negatives, all our important papers and a few changes of clothes. We evacuated to a motel in southern Alabama and tried not to watch the news. Monday, August 29 brought the convergence of two major life-changing events: the destruction of New Orleans and the birth of our first son. It was two long months and six thousand miles on the road before we were able to return home.

Hurricane Story is a depiction of our family's evacuation experience – the birth, the travels and the return. These photographs represent various elements of our ordeal. The project began as a cathartic way to process some of the lingering anger and anxiety over the bittersweet journey. It grew into a narrative series of self-portraits in toys that illustrate my experiences and emotional state during our time in exile.

We left in the dark of night.

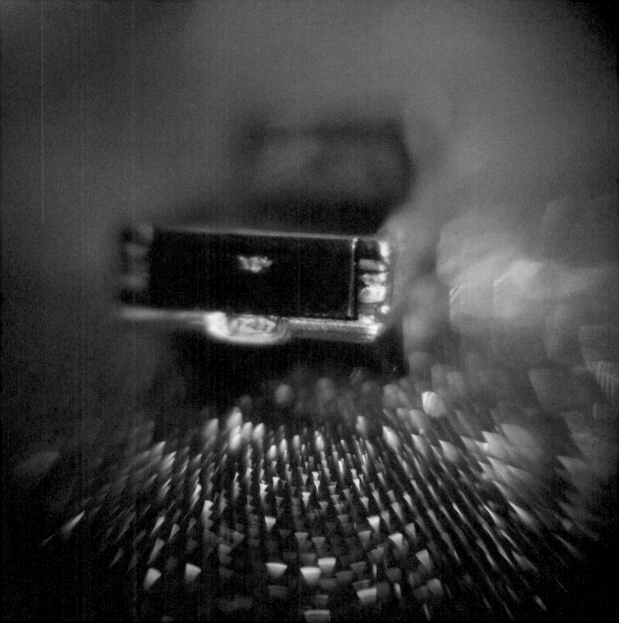

02

I was due in less than a week.

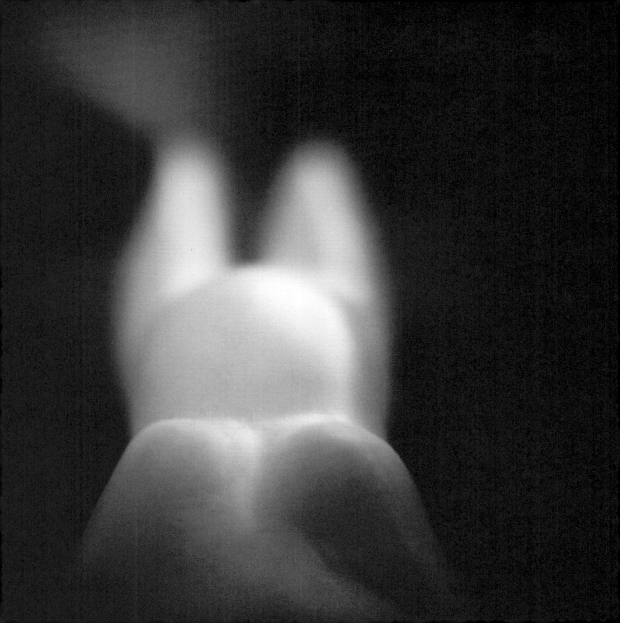

03

At the motel in Andalusia, we tried not to watch the news.

04

My water broke at one-thirty that morning.

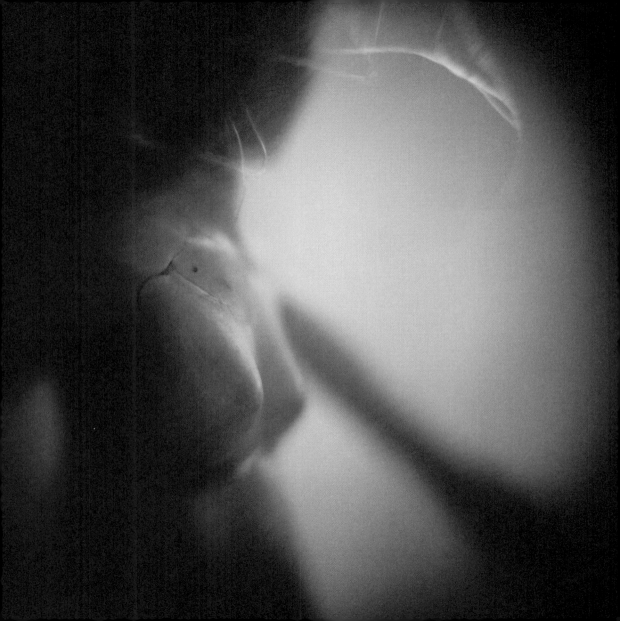

05

We sped for hours to an unfamiliar midwife.

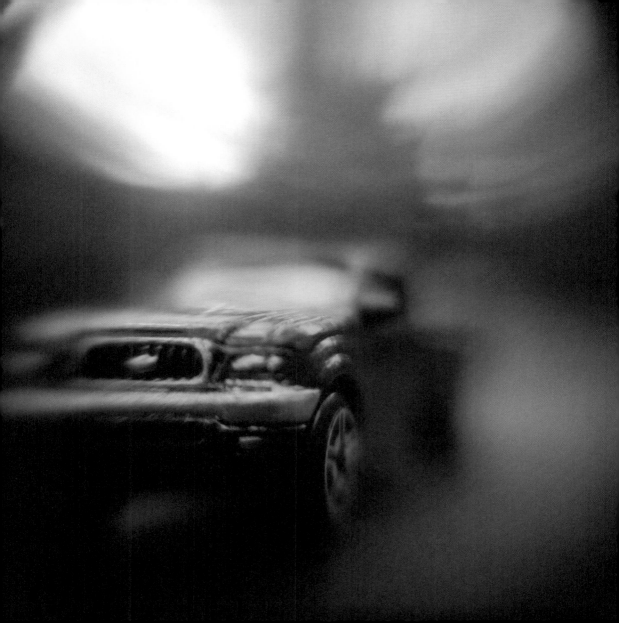

 06

Her eyes were beautiful, but the hazmat shield was distracting.

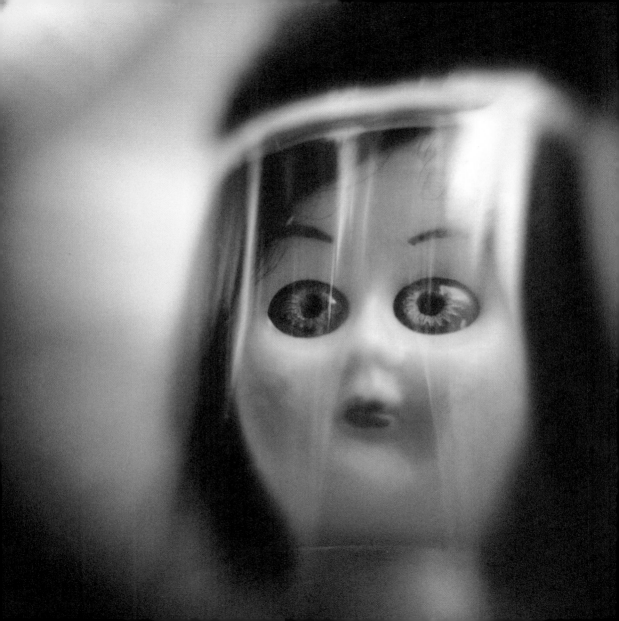

When we arrived at the hospital, it was time.

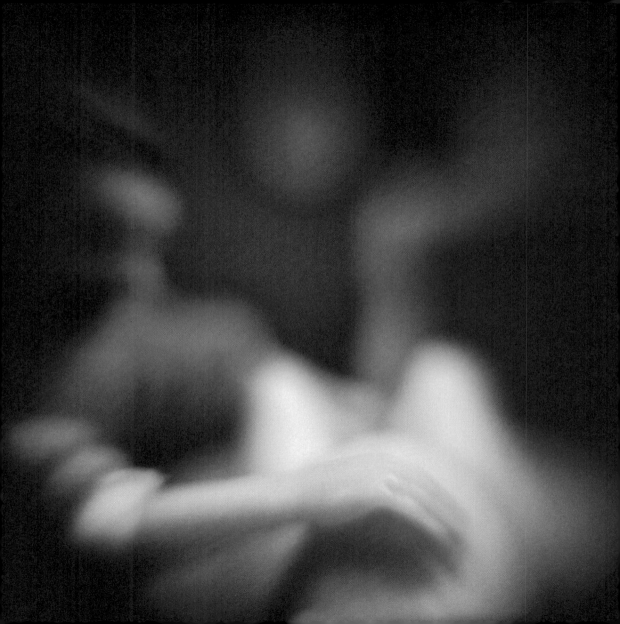

At 3:47 a boy was born.

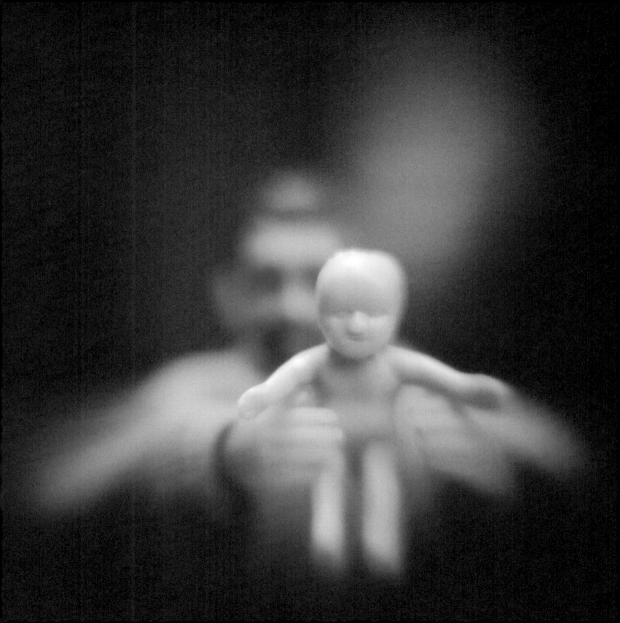

He was so tiny at first.

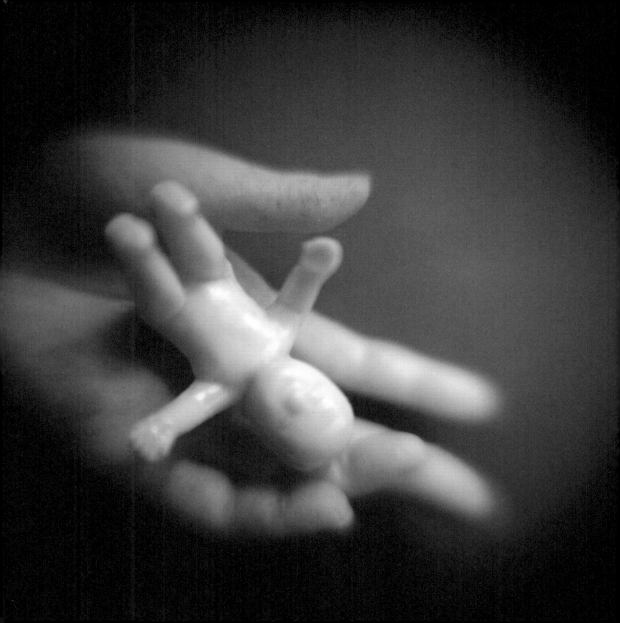

The next morning we turned on the TV.

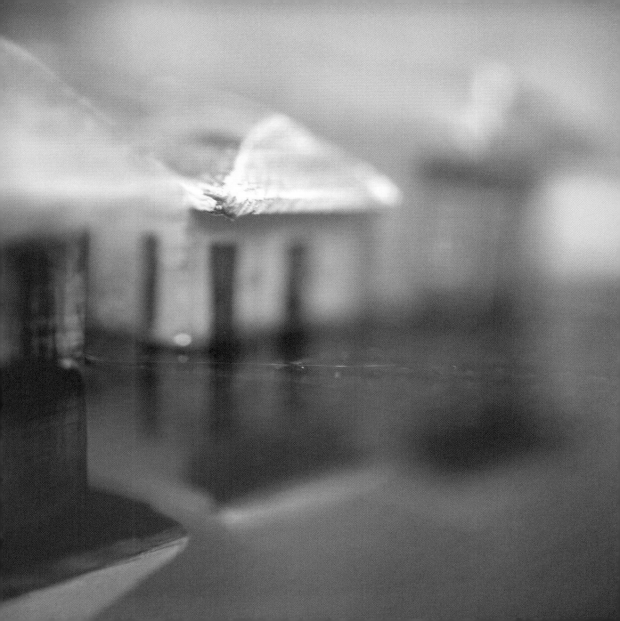

The news got worse and worse.

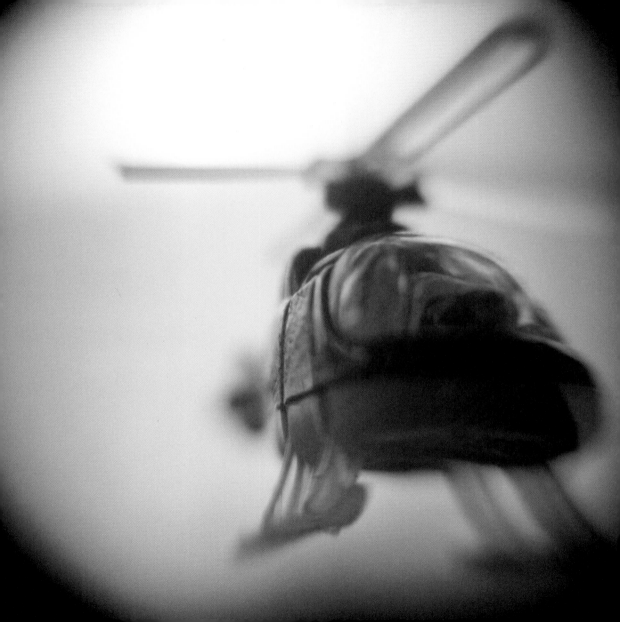

It was impossible not to watch.

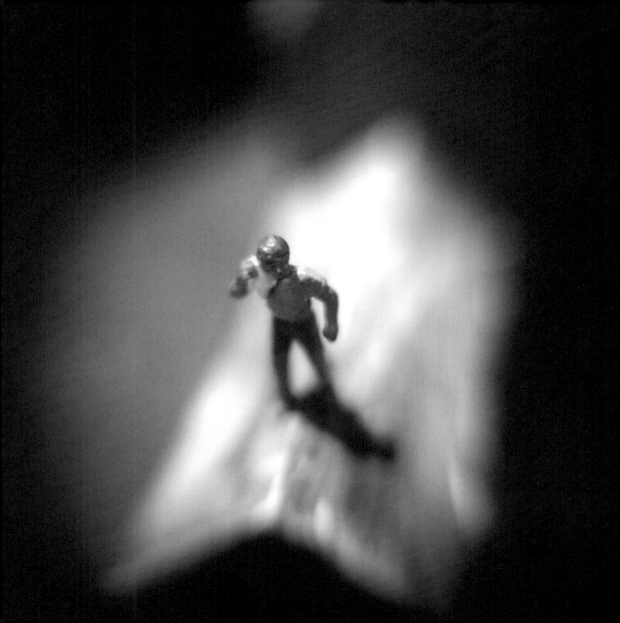

There were rumors of alligators in the streets.

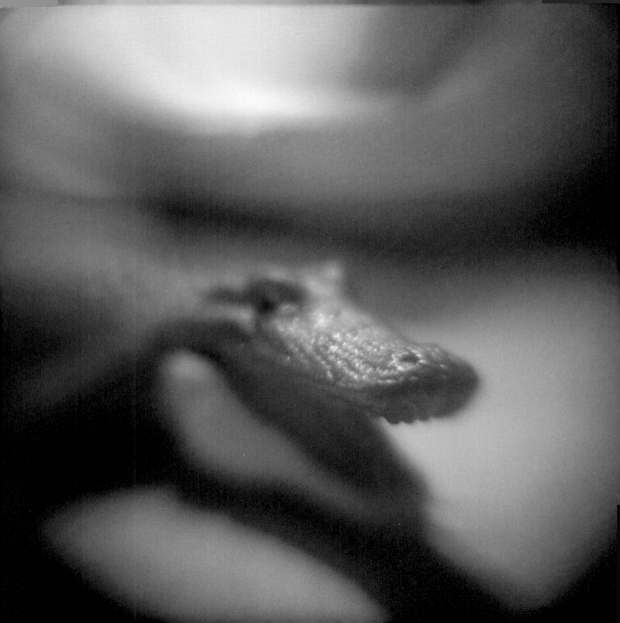

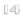

Ten thousand body bags seemed plausible.

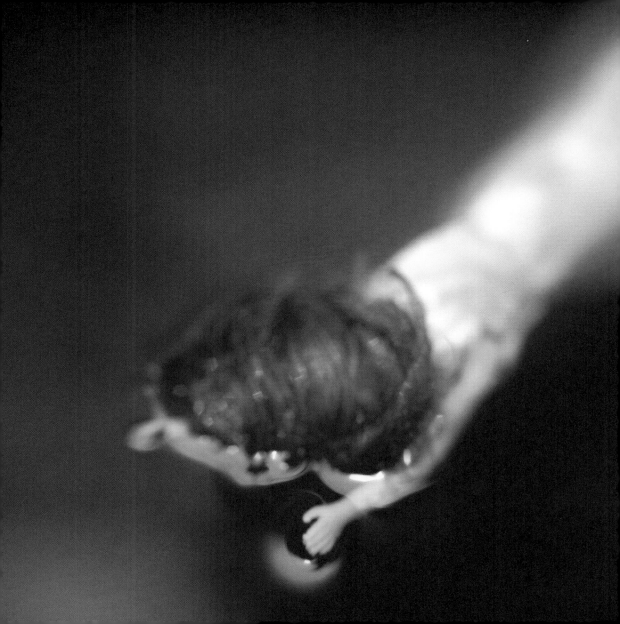

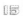

We dodged the flooding, but new fears arose.

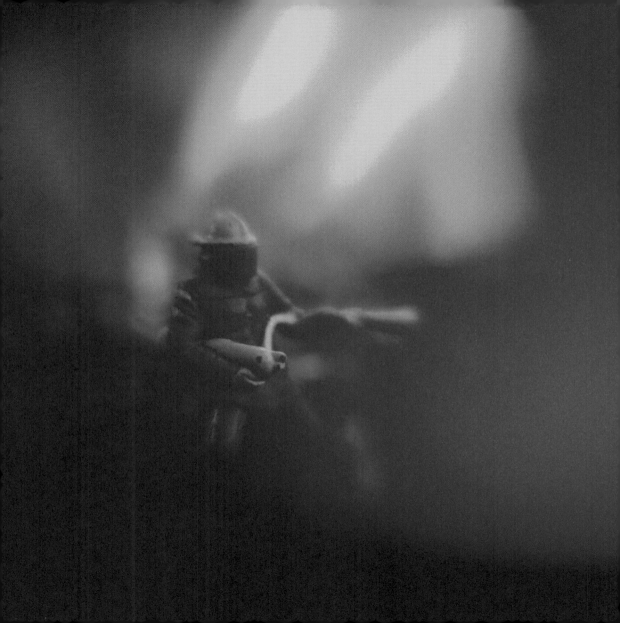

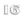

The chaos was hard to fathom.

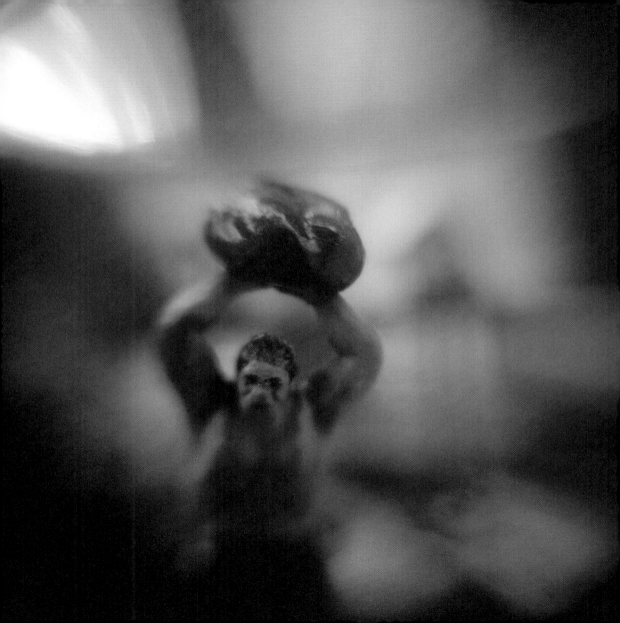

17

Send in the guard.

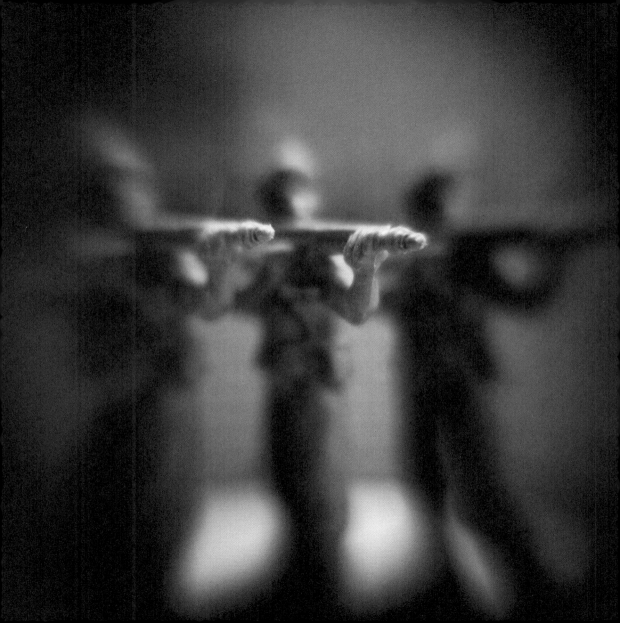

Kind people showered us with gifts.

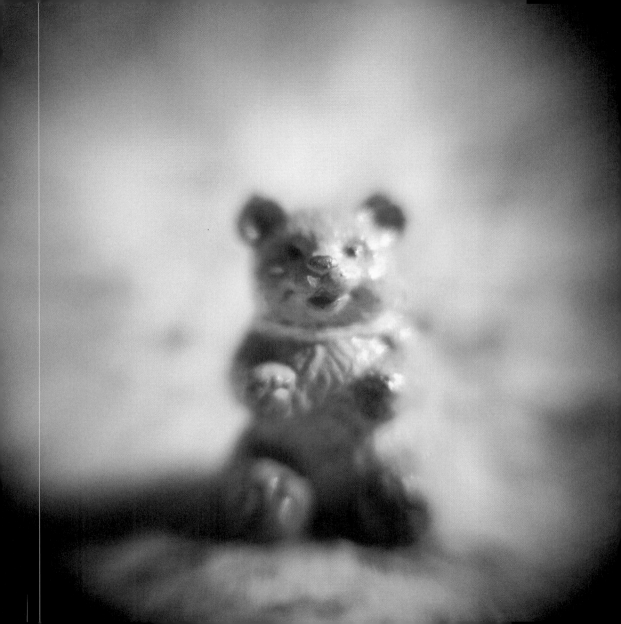

 19

It was nice to have a distraction.

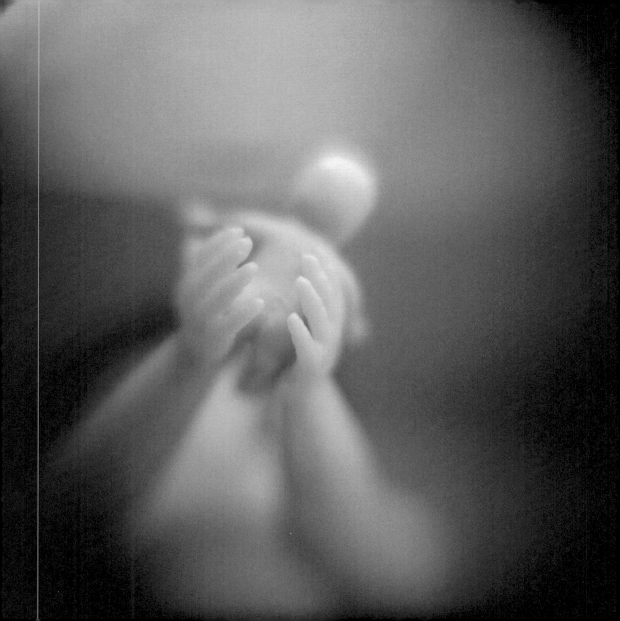

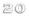

We drove further north to the farm.

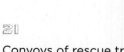

21

Convoys of rescue trucks passed in the other direction.

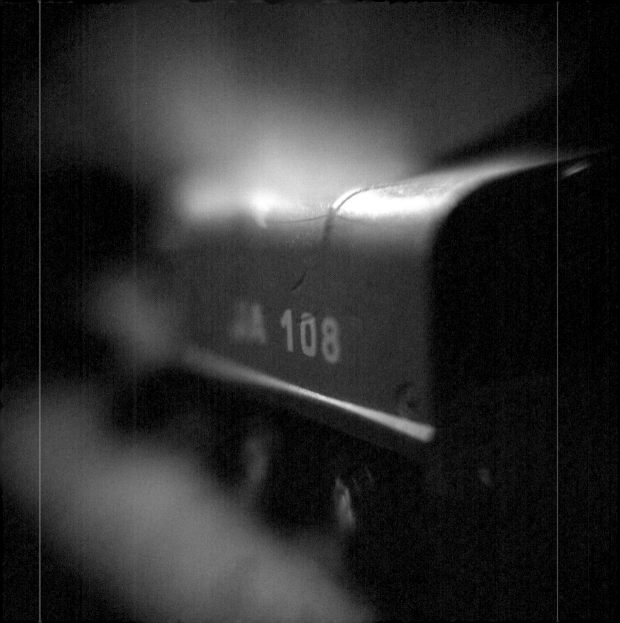

22

Jobs were offered and declined.

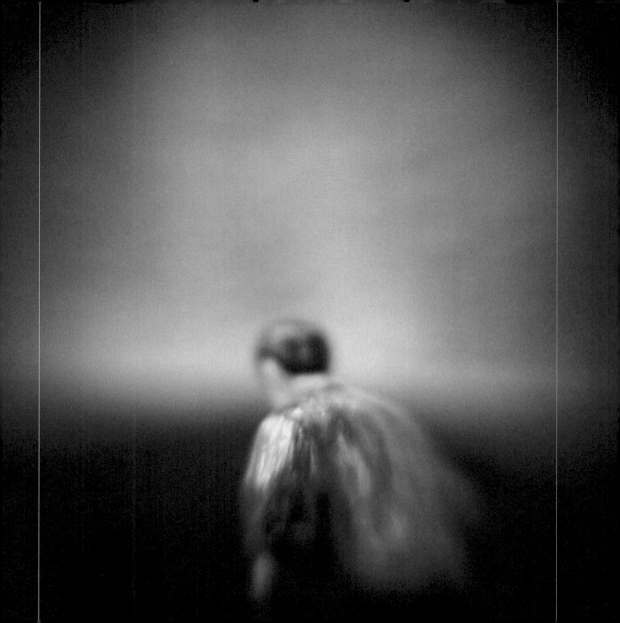

We took our hurricane sideshow on the road.

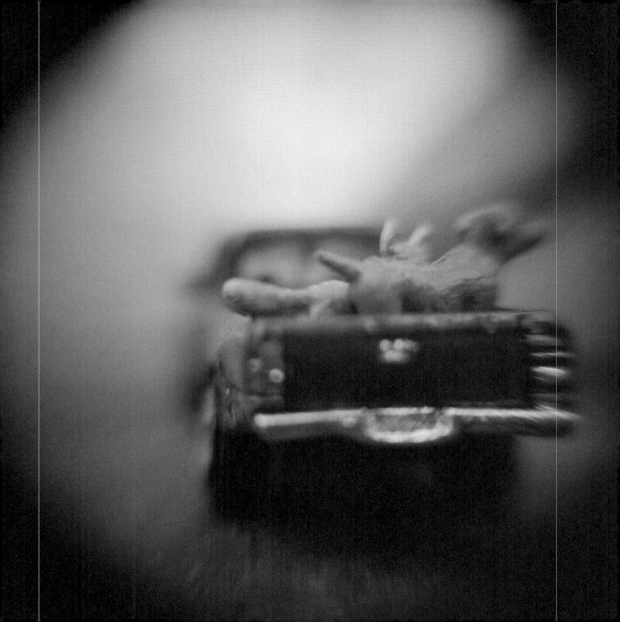

Family and friends were delighted to see us.

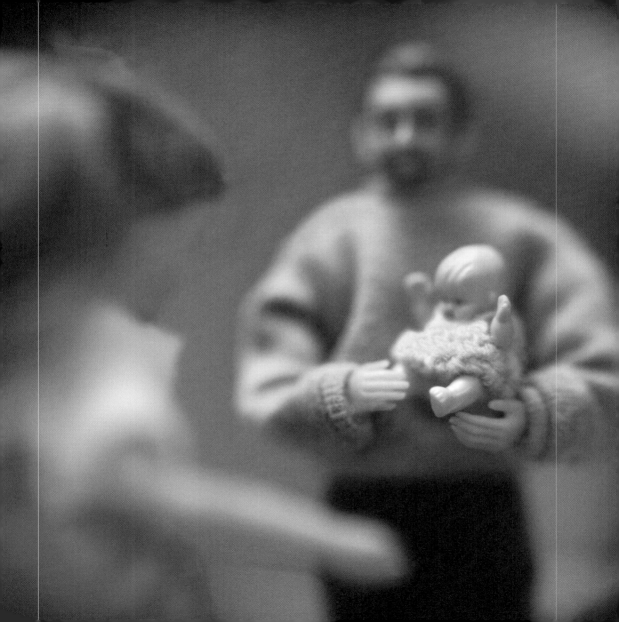

25

I'll confess that fall was beautiful.

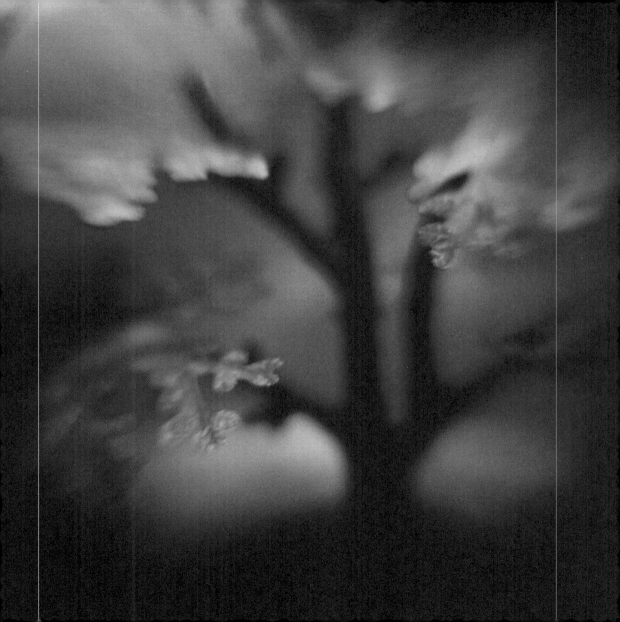

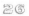
26

The dogs enjoyed their vacation.

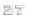

The gypsy life was harder on the cats.

28

My husband turned into a freak.

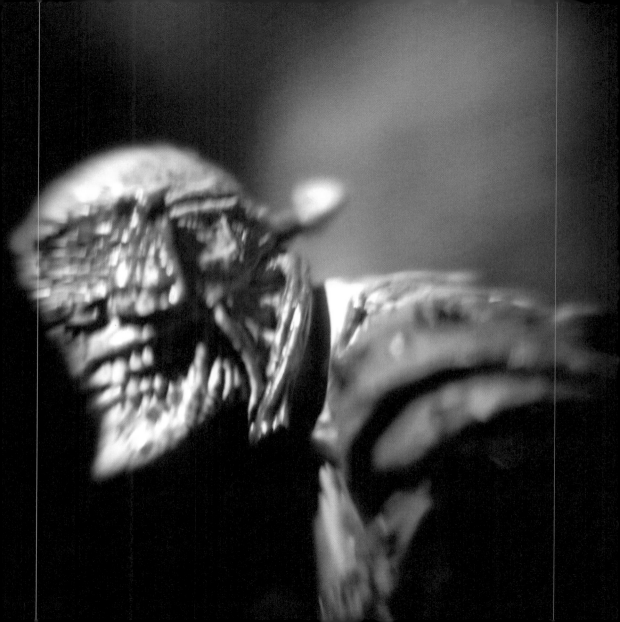

29

Violent fantasies ensued.

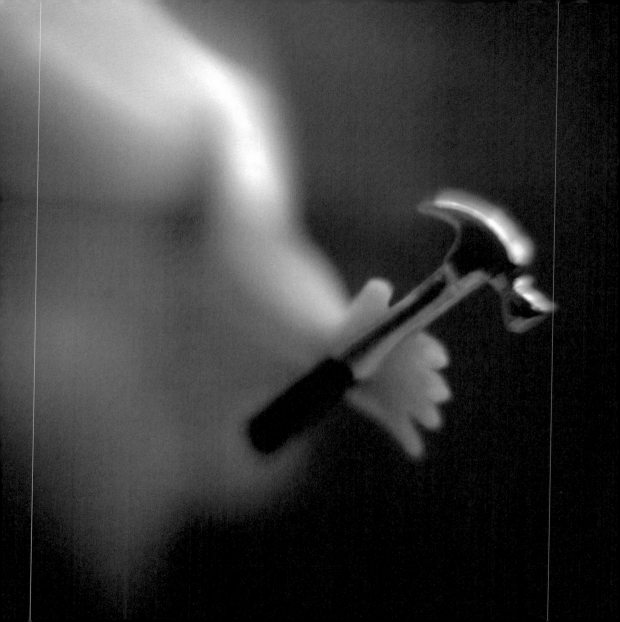

 30

Sometimes it felt like I had two infants.

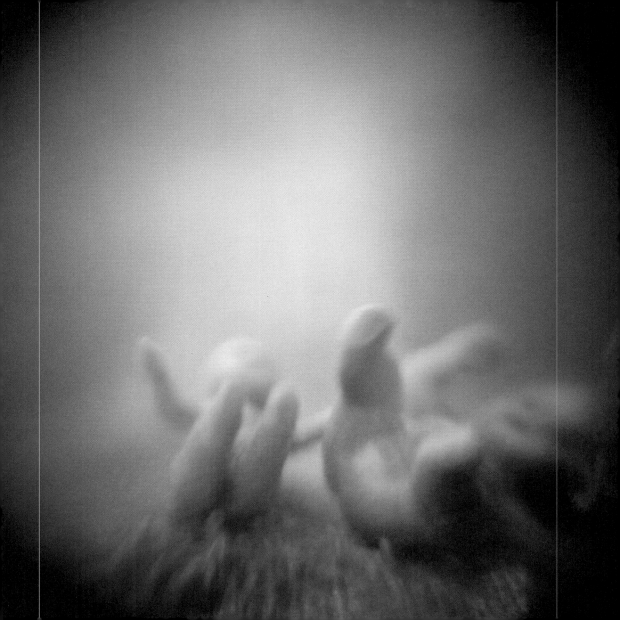

31

Bad habits resumed.

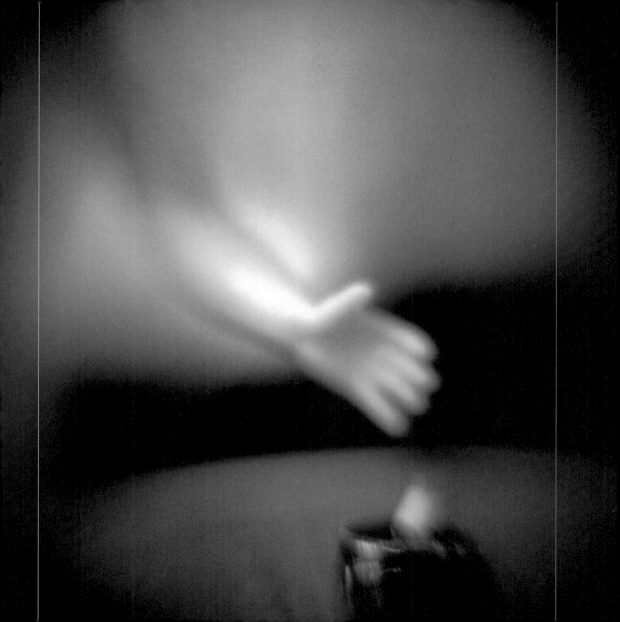

32

We scoured the Internet for updates.

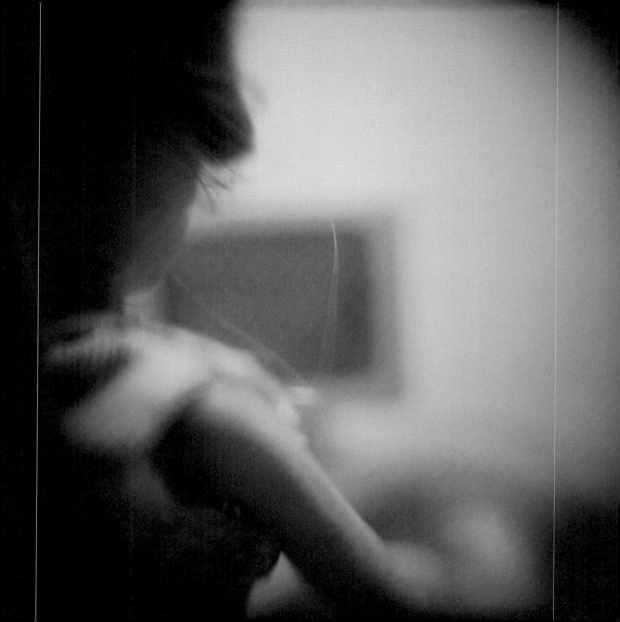

33

It was the longest two months of my life.

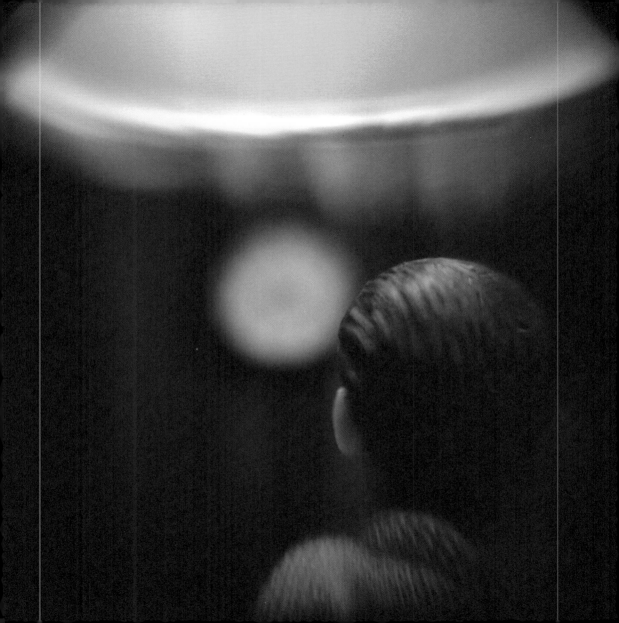

34

We drove home at the end of October.

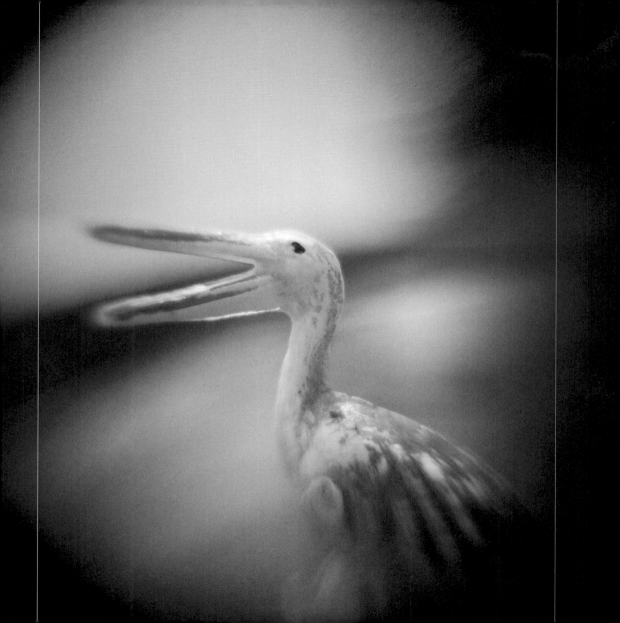

We passed a parade of drowned cars.

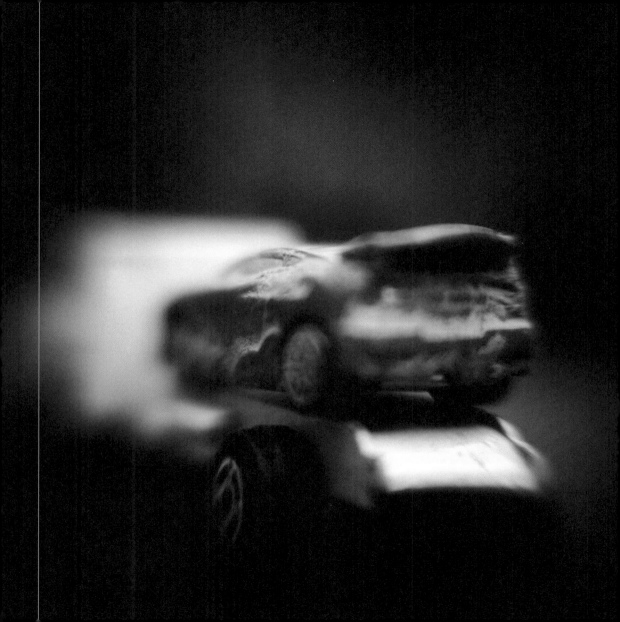

36

The city was strangely peaceful.

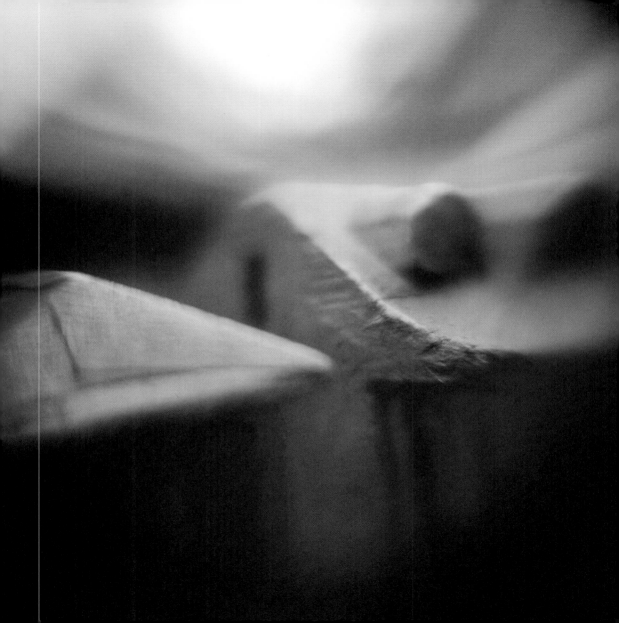

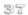
37

Mice had moved into the kitchen.

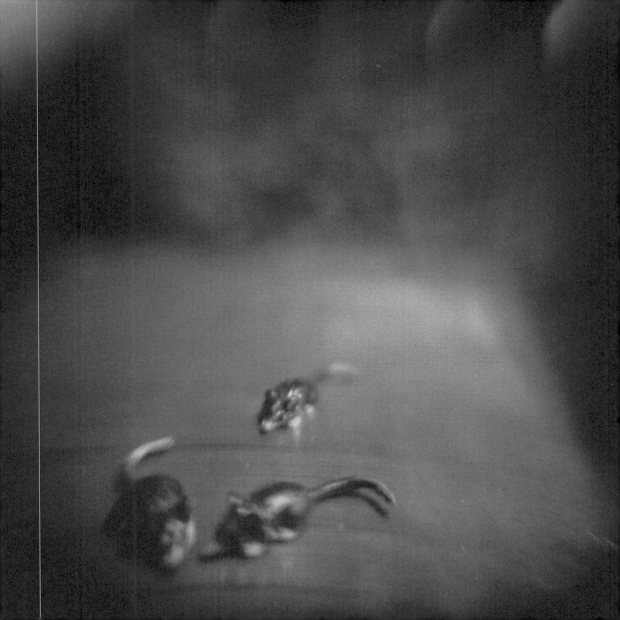

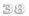

Nature claimed the fridge.

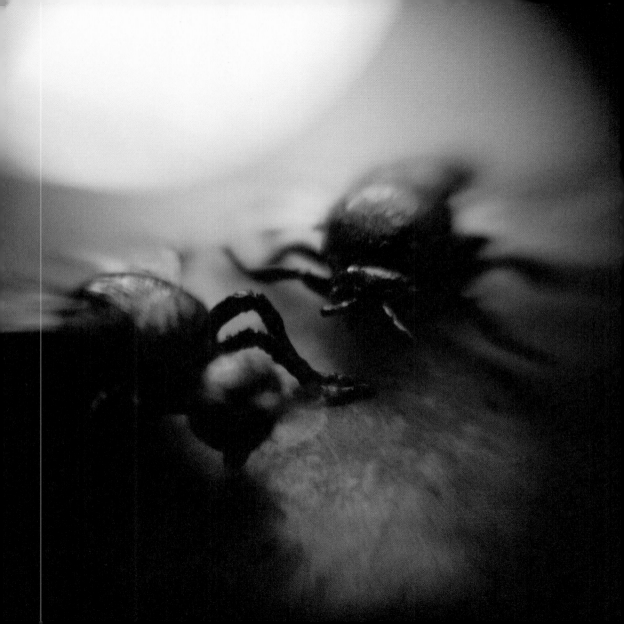

39

We attempted to drown our anxieties.

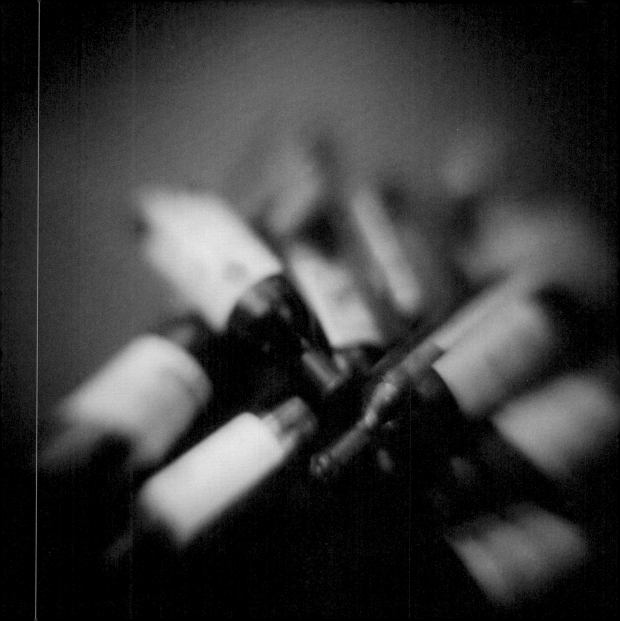

 40

Tanks in the streets soon seemed normal.

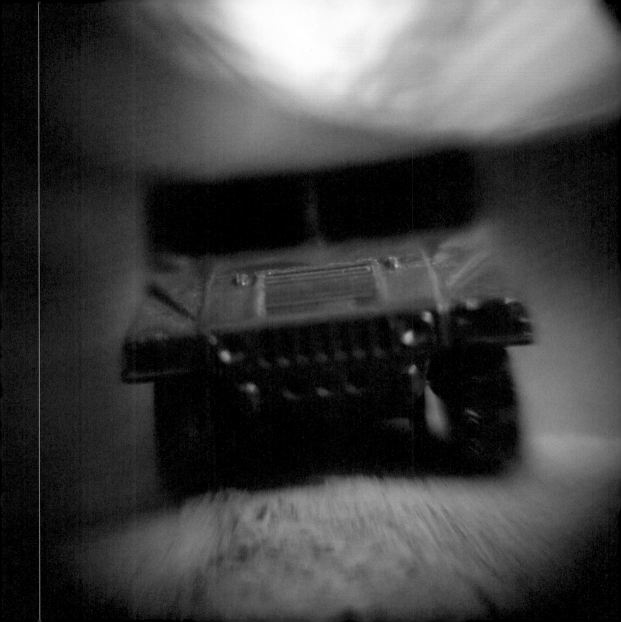

41

FEMA hauled off our downed trees.

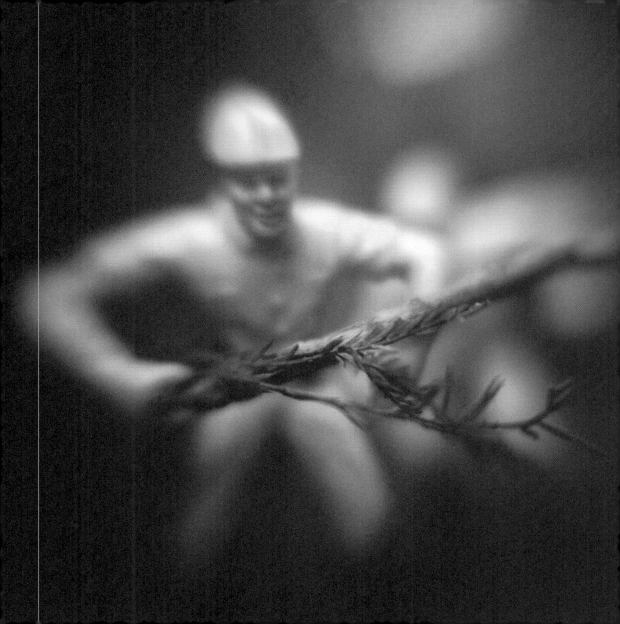

42

It was months till the phone was restored.

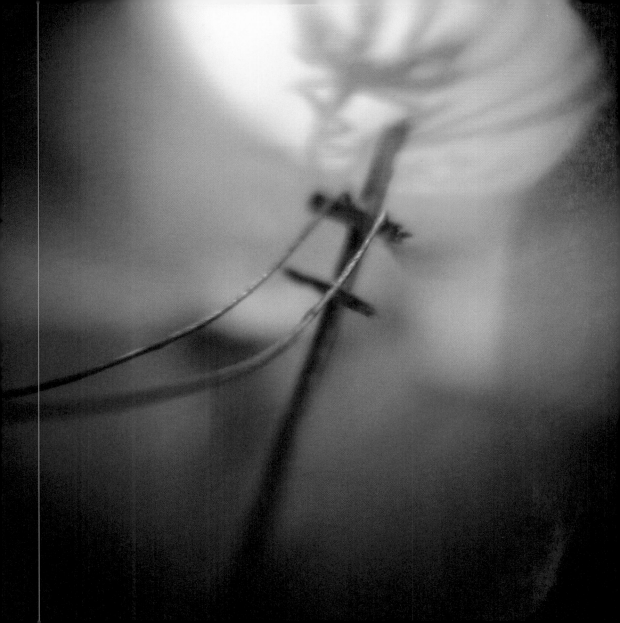

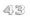

43

Slowly our friends trickled back.

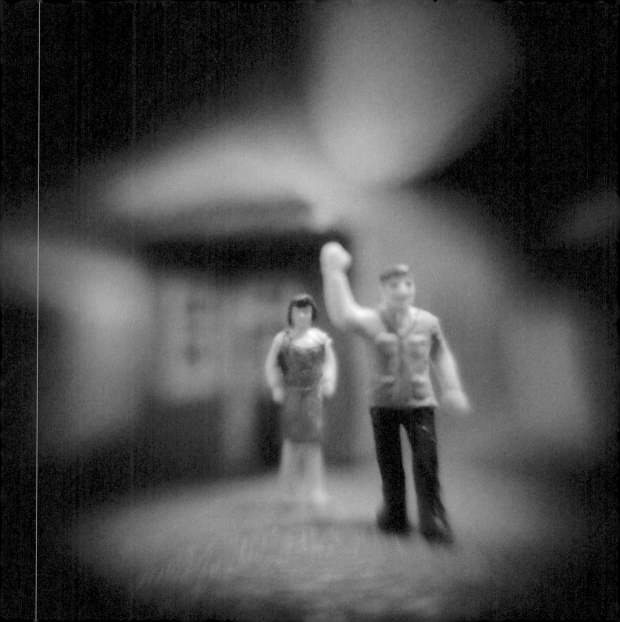

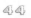

44

We got a new roof before Christmas.

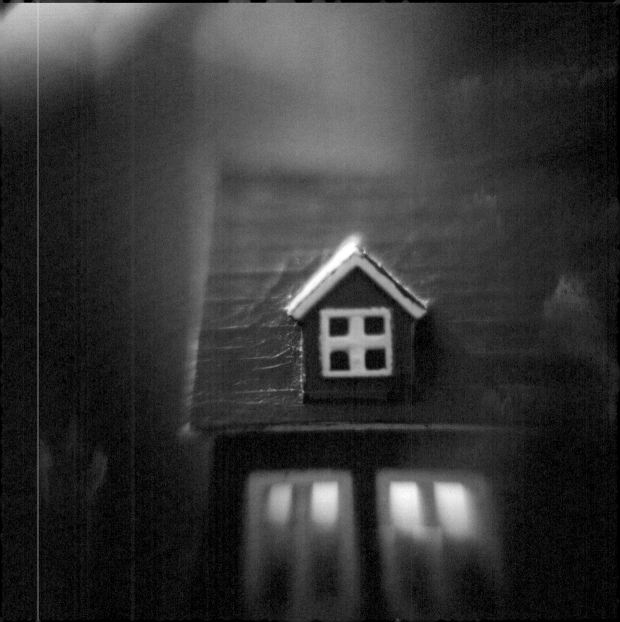

Mardi Gras was amazing.

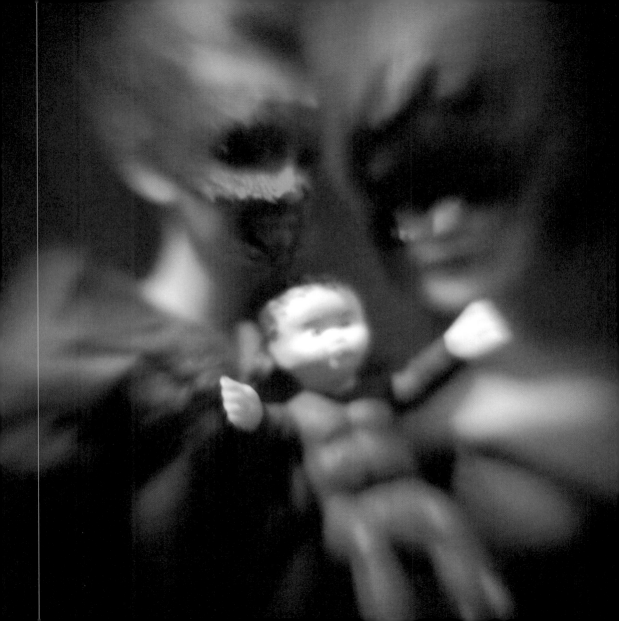

46

Anointed in glitter, we reclaimed the streets.

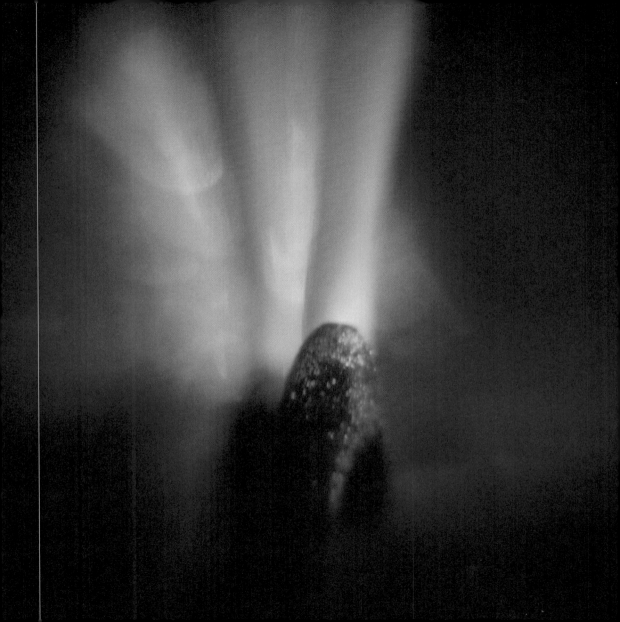

JENNIFER SHAW grew up in Milwaukee, studied photography at Rhode Island School of Design, then moved to New Orleans in pursuit of the artist's life. She teaches the disappearing art of darkroom photography at the Louise S. McGehee School and works as a fine-art photographer. She was a founding officer and board member of the New Orleans Photo Alliance and directs its annual PhotoNOLA festival, in addition to chasing after two young sons. Jennifer's photographs have been published in *B&W Magazine, Shots, Light Leaks Magazine, The Oxford American* and *The Sun*. Her work is exhibited internationally and held in private and public collections, including the Huntsville Museum of Art, the New Orleans Museum of Art and the Ogden Museum of Southern Art. Shaw has recently been featured in *Plastic Cameras: Toying With Creativity* (Focal Press, 2010) and *Before During After* (UNO Press, 2010).

ROB WALKER is the author of *Letters From New Orleans* and *Buying In: The Secret Dialogue Between What We Buy and Who We Are*, and a contributing writer for *The New York Times Magazine*. He is also the co-founder, with Joshua Glenn, of SignificantObjects.com (book version forthcoming in 2011 from Fantagraphics); co-founder, with Ellen Susan and G.K. Darby, of The Hypothetical Development Organization; and founding collaborator of the Unconsumption project (unconsumption.tumblr.com).

ACKNOWLEDGMENTS

With sincere thanks to all who helped us on our journey; this story wouldn't exist without you.

To my dear friends Stephen and Lisa Richardson and Janet Wilson, who were pivotal in getting us to Plan B, I am forever grateful. Thanks to my two midwives, Esther deJong and Roberta Ress, as well as The Athens-Limestone Hospital and their incredibly generous staff.

Many thanks to all of the family, friends and strangers who sent love in many forms during those months of uncertainty, including FEMA, The Red Cross and Salvation Army. It was amazing to be at the receiving end of such kindness and generosity.

I am especially grateful to the family and friends who sheltered us during the evacuation: Janet, Doris and Keith Wilson; Marie Green; Kathryn Davis and Eric Zencey; Maria De Sousa; Lisa and Stephen Richardson and Carol Mulready; Theresa Sousa; Suzanne and Carl Zencey; Nicole, Jane and Gregg Eiden; Megan Hougard and Eric Morrow; and Frank Shaw and Meral Savas.

I would also like to thank my husband, Cesar, whose support and patience have allowed me to create, and my children, Claudio and Mason, who remain continuing sources of inspiration.

There are many people who have advised and supported *Hurricane Story* in its various phases.

Deepest thanks to the friends who provided initial feedback and encouragement while the work was in progress: Janet Wilson, Ginny Kazmarek, David Halliday, Vanessa Brown, Jeff Louviere and Stephen Richardson.
I thank Bob Kubiak for the evacuation film, ToyCamera.com for teaching me how to build a macro camera, Nicole Eiden for the special run to Yankee Trader, and Thomas and Jared Richardson for unfettered access to the world's largest toy pile.

The Idea Village and the Louisiana Cultural Economy Foundation provided grant support that helped this project come to fruition. Sincere thanks to Charles Megnin of The New Orleans Darkroom for his generous assistance and Cameron Wood whose printing talents have been vital to the images.

I am grateful to those who have provided opportunities to bring *Hurricane Story* to a wider audience: Amy and Adam Farrington, Kevin Longino, Leslie Guthrie, Jennifer Schwartz, Bryce Lankard, Michael Mehl. I would also like to thank Aline Smithson, Allan Griffiths, Crista Dix, Jane Fulton Alt, Eric Keller and Stella Kramer for their generous support.

For advice and assistance in bringing this book into being, I thank Jan Bertman, G.K. Darby, Mary Virginia Swanson, Dave Anderson and Lori Waselchuk.

A special thank you to Rob Walker for his eloquent foreword and long-term support of the project.

I am indebted to the wonderful team at Chin Music Press: Thank you to Bruce Rutledge for believing in the work, Joshua Powell for his awesome design prowess, and Jenn Abel and Jessica Sattell for their guidance and contributions.

Last but not least, a great big thank you to everyone who has aided the recovery of New Orleans.

Jennifer Shaw
New Orleans
February 2011

A Broken Levee book
Broken Levee Books is an imprint of
Chin Music Press.

Chin Music Press Inc.
2621 24th Ave W
Seattle, WA 98199
USA

www.chinmusicpress.com

Book design by Joshua Powell
Set in Gotham Rounded, Cyclone and Delancey
from Hoefler & Frere-Jones
Printed in China with Asia Pacific Offset
Library of Congress Cataloging-in-Publication Data
is available.

{ CHIN MUSIC PRESS }

★★★★

№0012